Reflections

OF THE UNKNOWN

PORTLAND ORE. USA

KAREN WIPPICH is a Portland artist who breathes new life and color into old faces of strangers, creating vintage portraits with a warped, modern twist.

TOM VANDEL is a Portland copywriter who drives short shifts for Uber in his off time, getting a brief glimpse into the lives of random strangers coming and going at all hours.

Note: earnings listed are approximate net. Calculated as 80% of Uber fare, after $1 fee per ride, minus gas and depreciation.

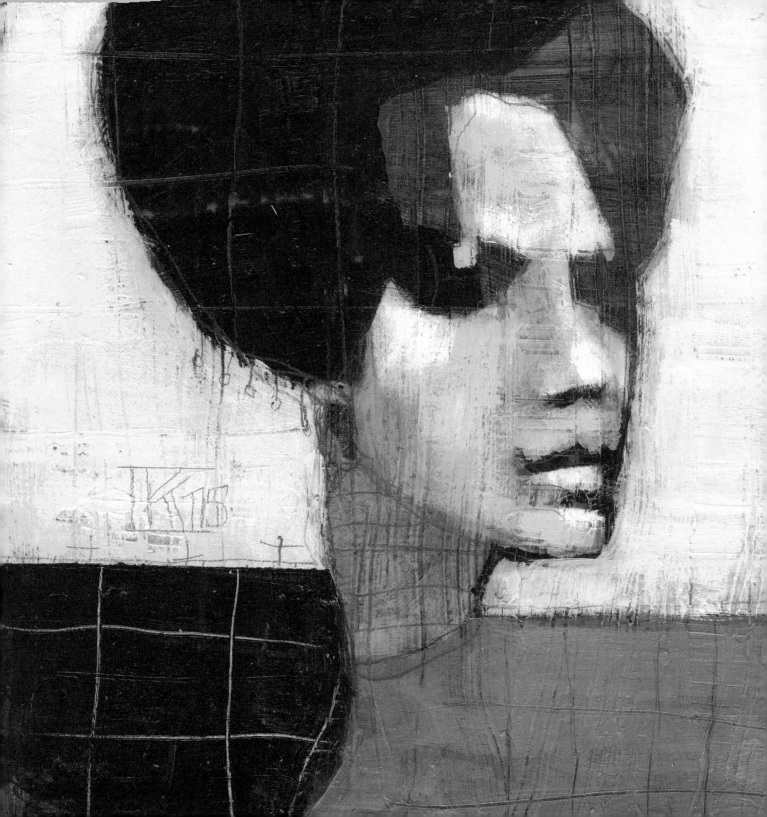

JULIAN – my first Uber drive. I take him to PDX to fly back to Oakland where he works as a coder for Pandora. Said of course he listens to Pandora at work – as in what a stupid question. I'm chastened. Can see I need to come up with better questions. Jules sat front seat. Wonder if there's a pattern to where people sit.

ANDREA – works for touring bands (Decemberists, Dave Matthews) as a merch seller. Flies out for tours and travels with band on their bus. Likes it but says it's not for everyone. I pick her up at Alamo Rental. Her car is broken down so she rented one. I take her home. Sooo tired she says. Probably has laundry to do. Rock on, sister. Sat back seat.

BARB – she pings me from Mt. Tabor area and I take her to PDX. Flying home to San Fran where she owns a boutique catering firm. Before I can start in with questions, she asks what I do. I give her my freelance copywriter/ad guy spiel. Says she needs to update her website and asks for my card. I fumble around and find one. Back seater. Made mental note: get more cards.

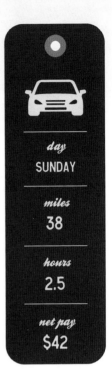

day
SUNDAY

miles
38

hours
2.5

net pay
$42

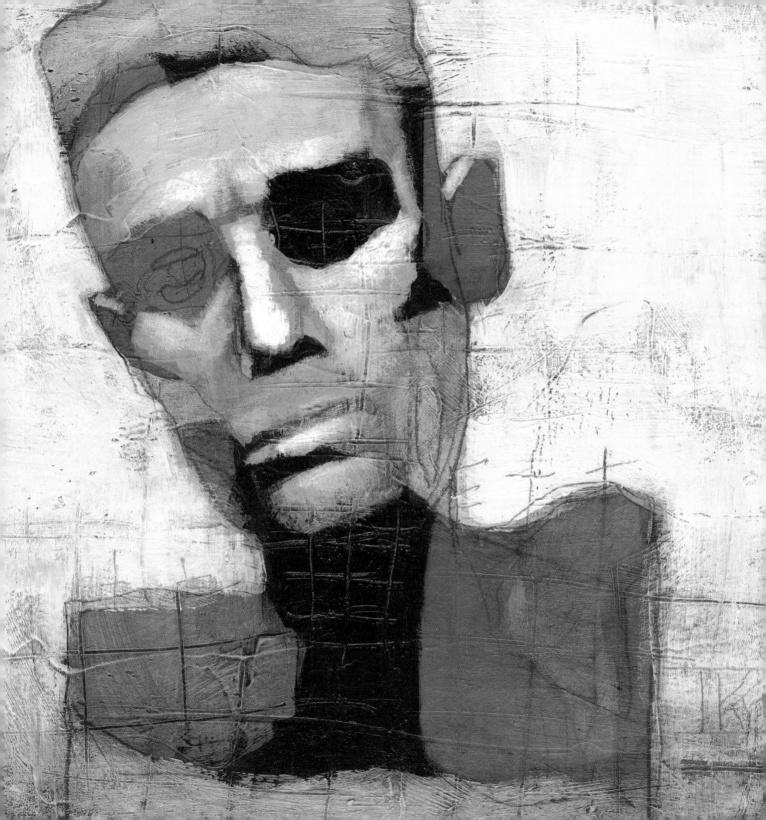

GERALD — dapper gent, older than I it appears, and trimmer. Owns a food company in Seattle. I drive him to Troutdale Airport where he has a plane. Plans to fly home for dinner with family. Was in Portland for two hours to check his company's booth at a trade show. Faint scent of saffron and old money. I hate him. Sat up front.

WOMAN AND MAN — didn't get names. Both in a rock band at end of a tour. Play tonight at Analog. I drop them at Church, one of my favorite bars (tagline: Eat, Drink, Repent). Almost clock out and go in with them. The guy's been boozing – thick whisky aroma. Shit, man, can't ya wait until after your show? Rock star he ain't but he drinks like one. Both sat in back.

JESSE — take him to PDX. He's a Sales Engineer for Cisco. For a kick I say, Cisco? The cooking oil? Three seconds pass. No, that's Crisco. Oh, right. So what you do is engineer sales? How do ya do that? He answers, you fly around and have meetings. Before I can conjure another inquiry his phone pops up. Don't want to be a "talky Uber driver" so I zip it.

day
TUESDAY

miles
46

hours
3

net pay
$55

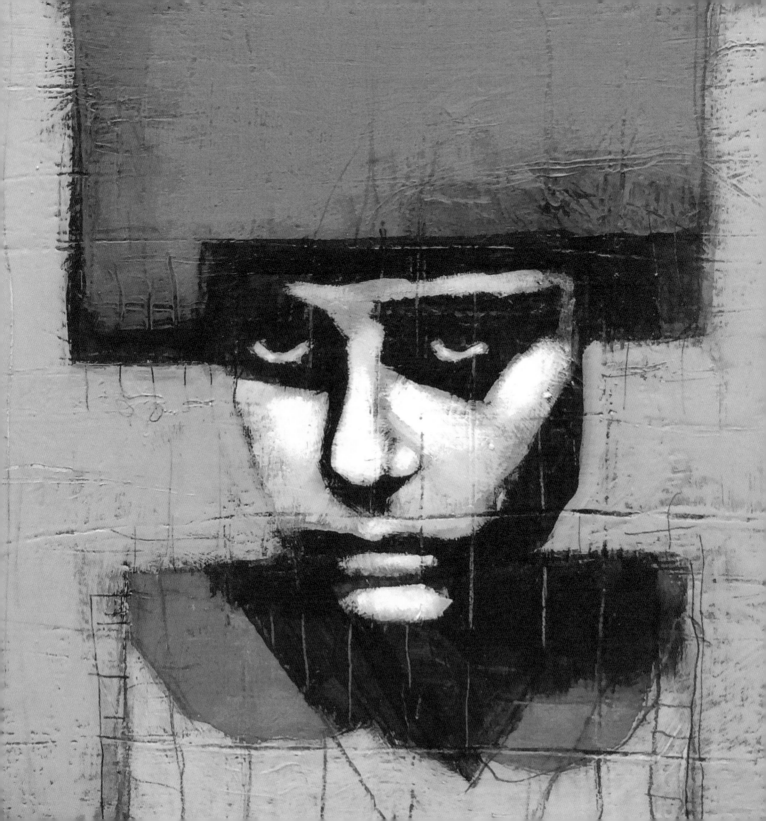

KENDRA — works for mobile ad firm. She met today with W&K and other ad agencies. I deliver her to PDX for flight back to "SF" as she says. On phone with coworker all the way talking loudly. I hear it all — I am a robot. "You killed it! You rocked in that meeting. They're idiots if they don't go with us." I hope they don't. Back seat.

WOMAN AND BOYFRIEND — I stifle the urge to tell her to shut up. After picking them up at another favorite haunt, Roadside Attraction, she instantly starts ripping her boyfriend. Says he's too rough around the edges for Portland. Roughly: "This city is more sophisticated than you." He yells, "Bullshit, I'm from LA, I can fit in here!" She retorts, "I don't know about you. You've already been written up once. You better not be manipulating me!" He asks what I think. "You'll fit in fine." Both sit in back (she glaring).

MAX — grew up in Switzerland, moved to NYC, and now lives in Portland. Works for high tech product design firm. Flying to SF to make presentation at Google. He and his team were up for two nights straight soldering devices to show client. Ah, to be young and driven. Back seat.

day
WEDNESDAY

miles
39

hours
2

net pay
$42

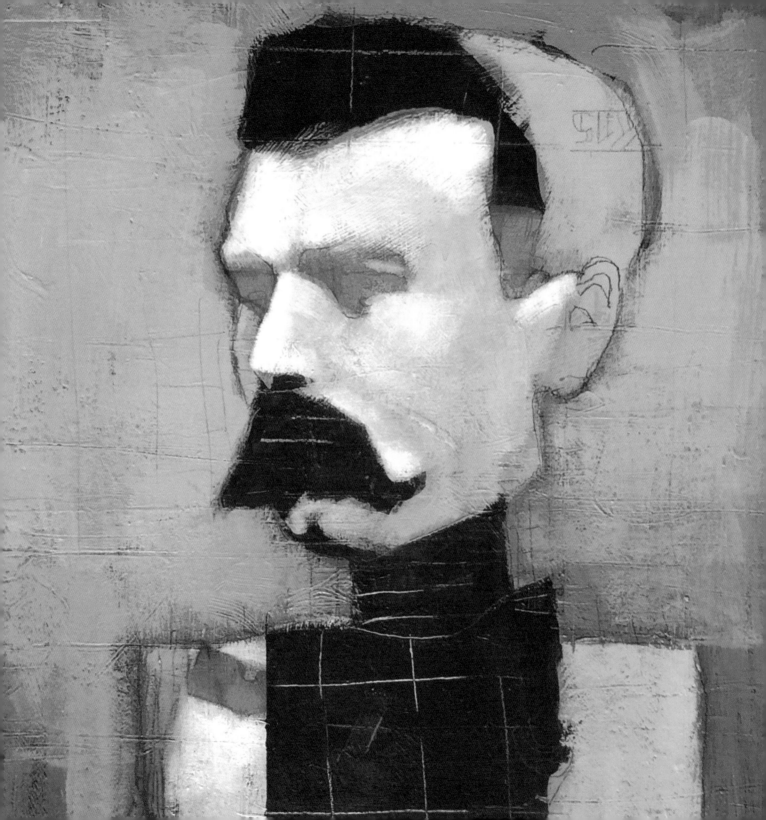

SKYLER AND FRIEND — they ping me from some kind of warehouse party. I say it looks like a fun time. "You should be there," they respond, "it's the Portland Uber launch party." I think WTF? Nobody told me. I woulda gone to that. Take them to NW Portland where one lives in a hip work/home space she manages. Then I head back towards the party, out to crash it. Both sat back seat.

STEVE — before I can make it back to the Uber party I get a fare. I pick him up downtown and take him to his home in NE. He's boss of a national account team for some Blah & Blah Company. They meet in different cities for quarterly meetings and eat and cavort on the company tab. I hate people with jobs like that. Wish I had one. Front seat.

AARON — finally get back to Uber party and as I pull up I get pinged — from someone at the party. Grrrr... So I sit outside and wait, and wait. I call him. He says to start meter. Five minutes later he saunters out. Lives in NYC. Seems familiar with making common folks wait. I tell him the Knicks suck. Jets, too. He doesn't argue. Knows I'm right. Back seat.

day
THURSDAY

miles
38

hours
3

net pay
$55

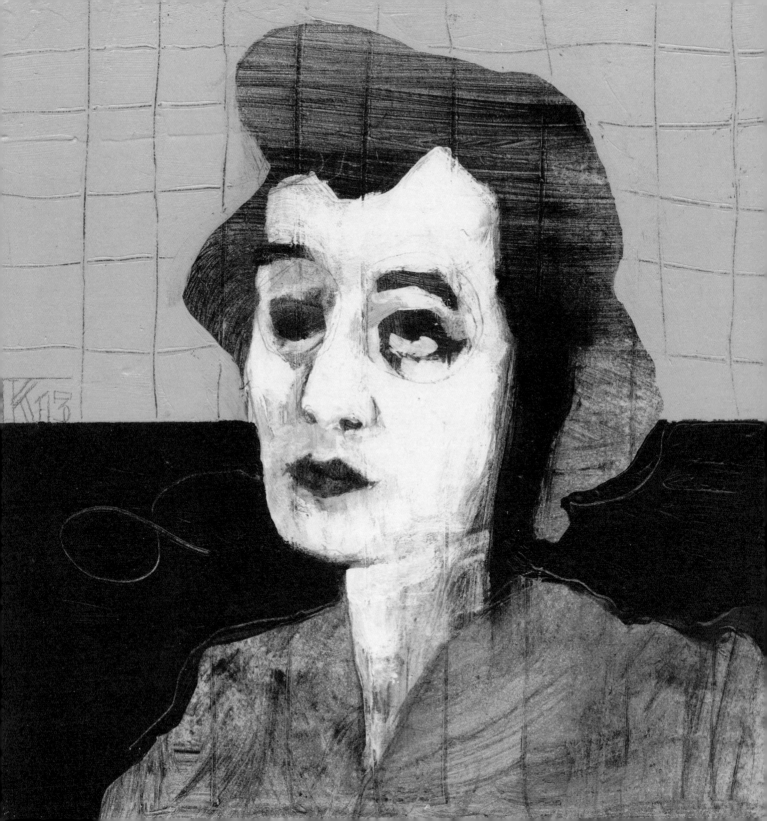

DELILAH — too much perfume, too much perfume, too much perf... losing consciousness.

ANATOLY – he gets in and immediately turns up the radio and reclines the seat. Kinda ballsy. Seems PO'd. Tells me his buddy was supposed to take him to airport but never showed. As we're heading out 84 his pal texts – says he's stuck in traffic heading in. Anatoly blows him off. Says he's a good friend but a fuckup. Been there. Front seat, reclined.

BRIAN — pings me from Portland Art Museum. I drive him to his apartment in Beaverton. He's an IT guy who works for a major hotel chain. Hackers try to get in, he bars the door. Travels a lot. Loves his job, but I wonder. Sounds lonely as he looks out window. Probably no plans tonight. Back seat.

RHONDA AND MATT — pick them up at Kennedy School and mistakenly take them to NE Davis instead of NW Davis. Uh, oops. I apologize and hope they don't ding me for it. No sweat. More interested in themselves. She asks him if he got a bow tie for the party yet. Mmm, no. Well, you'd better she harps – everyone will be dressed up. He promises, but I'm not convinced. Bet they break up. Back seat.

The side tag reads:

day
FRIDAY

miles
55

hours
3.5

net pay
$66

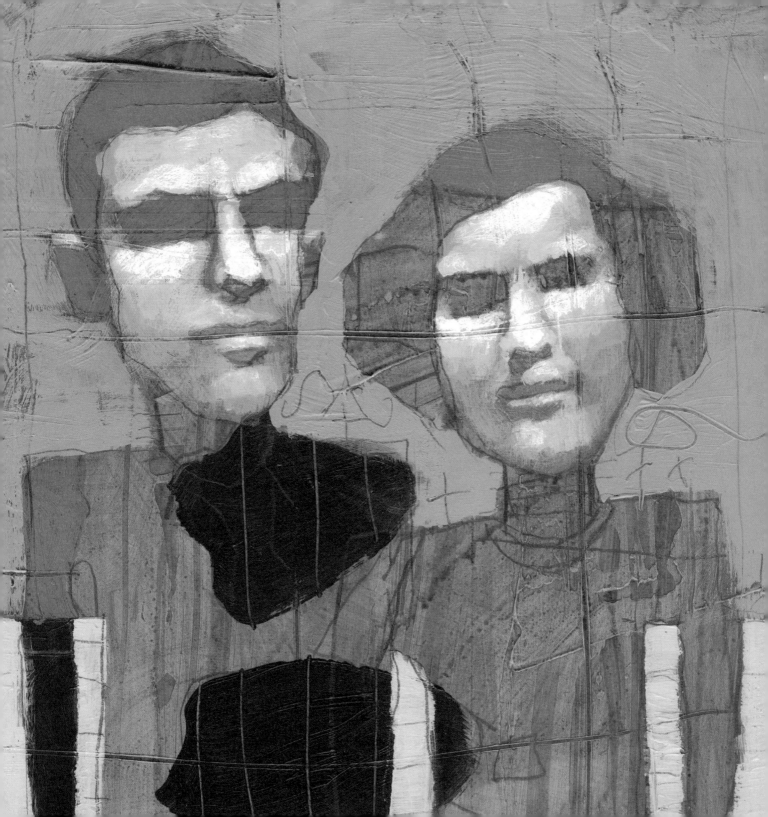

BRANDI — I imagine she's a blond, superficial, pop starlet type and am I ever wrong. Jumping into my front seat is a tall, thin Asian woman in skinny jeans with straight black hair. On her way home to LA. She owns a tax accounting firm and flies to Portland twice a month. Names can be deceiving. Sorry to brand you wrongly, Brandi. Front seat.

Note: From this point on I cease reporting where people sit. No rhyme or reason to it. Most sit in back.

TWO COUPLES — just finished dinner downtown. I take them to Beaverton. Long drive. Everyone talking over each other except one guy who doesn't utter a sound. When we arrive, mute guy opens his door and tumbles out face first on driveway. Stone cold drunk. Can't get up without help. I stay in car.

TIM AND WIFE – getting late. One more ride, then home. Get pinged from Paddy's downtown. Hope it's not back to Beaverton again. Instead, it's Happy Valley – Beaverton east. Two freeways and a long two—lane to their place in a suburban ho—hum cul de sac. They didn't say a word. All talked out, or having a fight I figure. Probably both.

day
SATURDAY

miles
94

hours
3

net pay
$65

PAGE
13

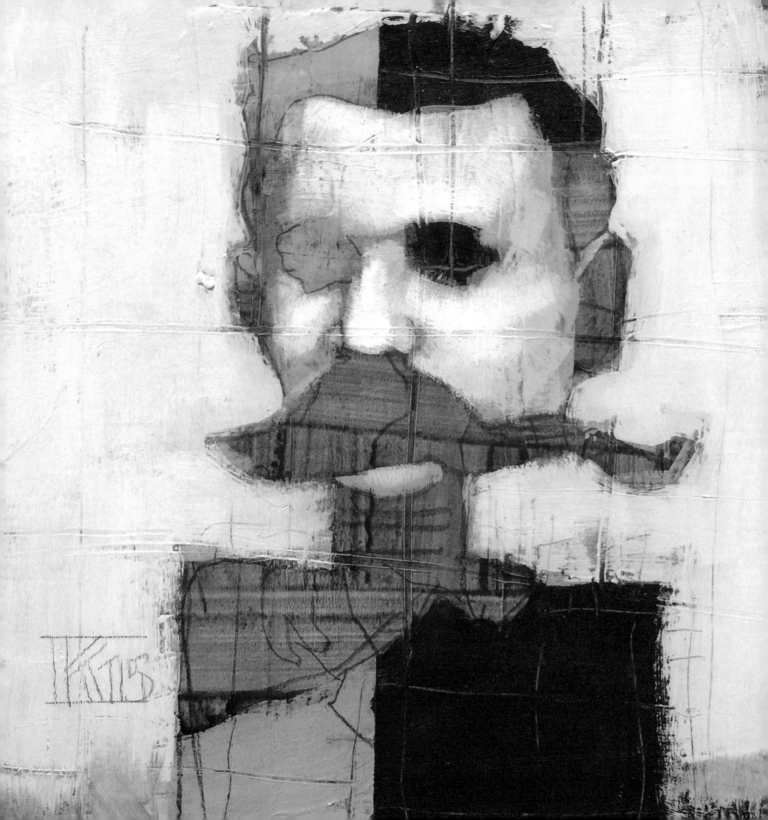

FRED — arrived in Portland via Amtrak from Seattle. I collect him from station and take him out 26 to a Beaverton business park. He's an engineer who owns a consulting firm. Gives me a $20 tip. I say you don't have to tip with Uber. He says he always does – it's a habit. Who am I to break a man from his habit? I pocket it and point back to town.

GEORGE — eyebrows grown crazy, like weeds. Don't these people ever look in the mirror? I can see the wild hairs in my rear view – sprouting out of each brow. Pick him up at Powell's Books and take him to hotel across river. An old vet (veterinarian, not military) in town for a conference. Hope ya brought some scissors, Captain Kangaroo.

HAVEN — young guy who pings me from Sunset Transit Center in Beaverton. Uber directions are wrong – have to take multiple turns to find him. He doesn't say much. Our age span is a chasm he doesn't care to cross. Buries his head in his phone and I mute myself.

day
SUNDAY

miles
43

hours
2.5

net pay
$46

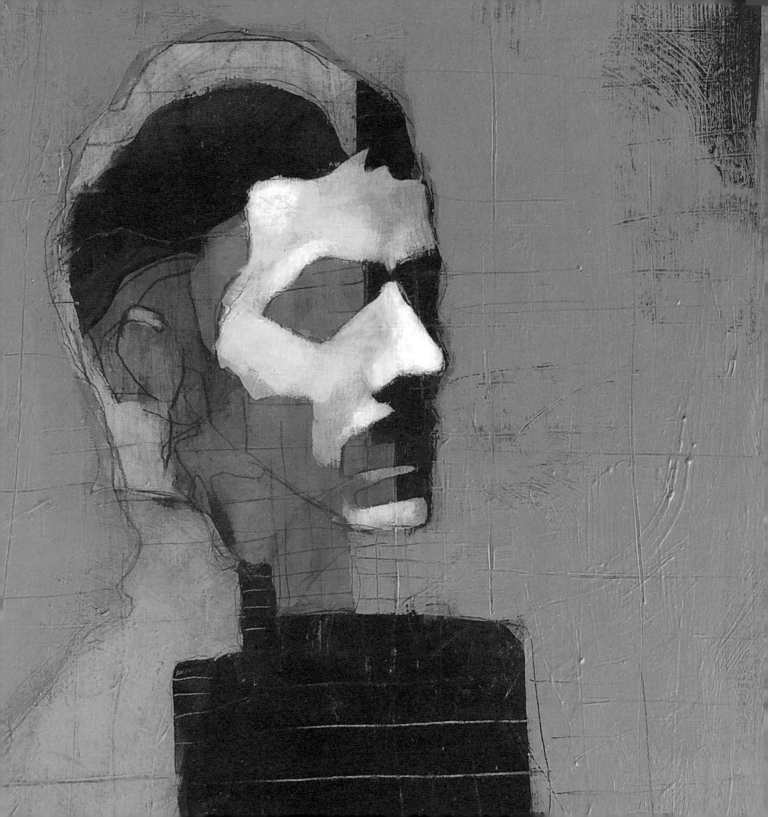

ALEXANDRA AND FRIEND — went way north Portland to pick them up. Took them to Bungalo Bar on Mississippi. Left their car there the night before – decided they were too hammered to drive. Can't tell if they're a couple. Alex recently moved here from Helena, Montana, out to make her way in the big city, just as I (also from Montana) did many years ago. Life is what you make it, not what ya make.

JEN — odd that I get the call since I'm downtown and she's in Milwaukie. I'm the closest driver to her? I take her to Lake Oswego for her first day of a new job. She missed her bus (not a good start), so called Uber. Moved to Portland two months ago from Jacksonville, Florida. Thinks Oregonians are waaay laid back, nicer than the "wackos" in Florida. In laid back style, I suggest she buy an alarm clock.

CHARLES — I drop him at Sheridan's Meat Market. Claims he wants to buy milk before going to work. He's a nerdy, serious product designer with his own firm. Originally from Dublin. I say have a good one, mate. My accent sucks – but the milquetoast smiles.

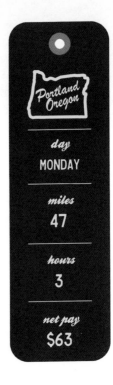

Portland Oregon

day
MONDAY

miles
47

hours
3

net pay
$63

PAGE
17

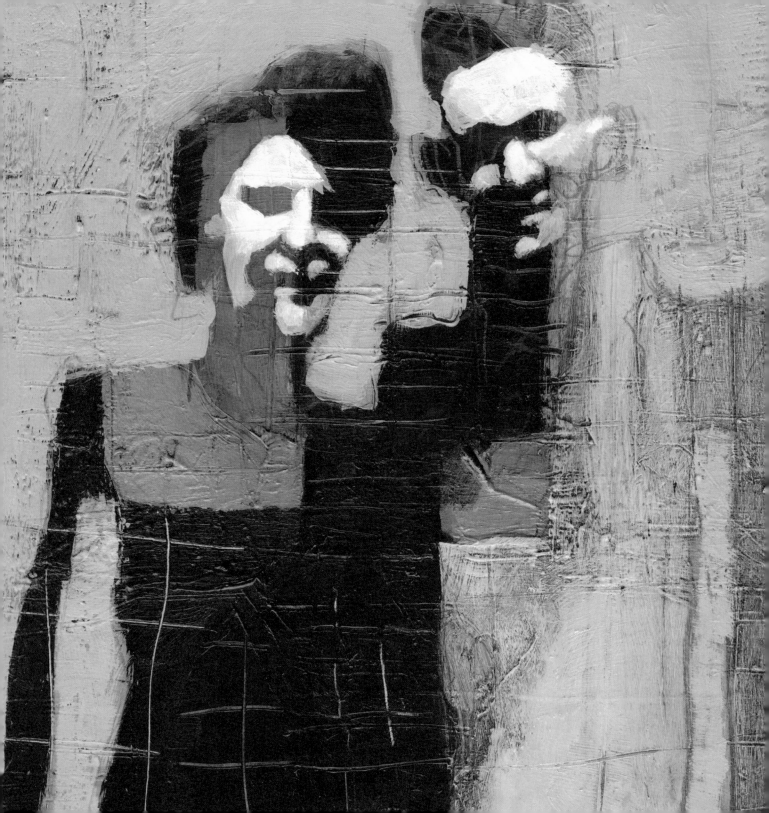

CHERRY — I see her walking towards me as I'm parked just off Burnside. She slides in and I can tell she's crying. I ask how she is. Better now, cause I just kicked my jerk boyfriend out. Sniffs and sobs. He never paid a cent of rent and all he does is sit around getting high. I can't take it, she says. He's a leech. I tell her she was smart to give him the boot. I drop her at a friend's place. Some guys are assholes. It's a fact.

TERRANCE AND BUDDY — pick them up at Motel 6 and take them to car rental near airport. Aussies here to drive around the U.S. Going to SF, LA, Vegas, New Orleans and NYC. They wonder why people say to skip Vegas – want to know what I think. I advise them to hit Vegas hard and see the underside of the USA. Go down under in the American desert.

BRENT AND WIFE — pick them up at OMSI outdoor party and shuttle them home. All dolled up. Bringing home a box of Voodoo donuts for their kids. I hear them talking about a Hollywood project. I lean back to eavesdrop better. Then bust out and ask what they're up to. Turns out it's "shopping around" a script. I look right to show my best side.

day
SUNDAY

miles
39

hours
2

net pay
$42

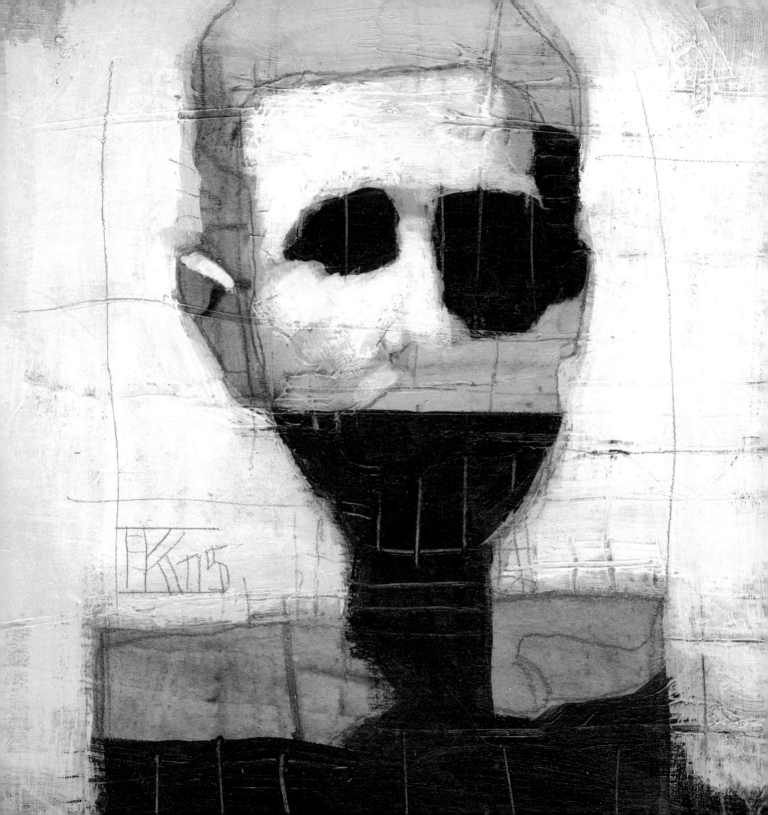

THERESA — take her to a job interview. Nervous, wants to be there early. Works as insurance underwriter but is now in a rut and wants to move on. I prop her up and pepper her with moronic, smart—ass questions. What kind of tree would you be, I ask. She takes me seriously and says a Douglas Fir. Why a fir? It makes me think of Christmas. Good answer. I'd hire her.

DARRON — I drive from NE Portland across river to Good Sam Hospital. After five minutes I call him. No answer. Leave a message. Three minutes later I call again and leave another message. I say I'm outta here soon if I don't hear back. One minute later he cancels. C'mon, man! Really? Probably a doc taking too long to close up a chest, or answering some stupid patient's question about a goddamn hip replacement or something. I hate hospitals.

day
TUESDAY

miles
46

hours
2.5

net pay
$54

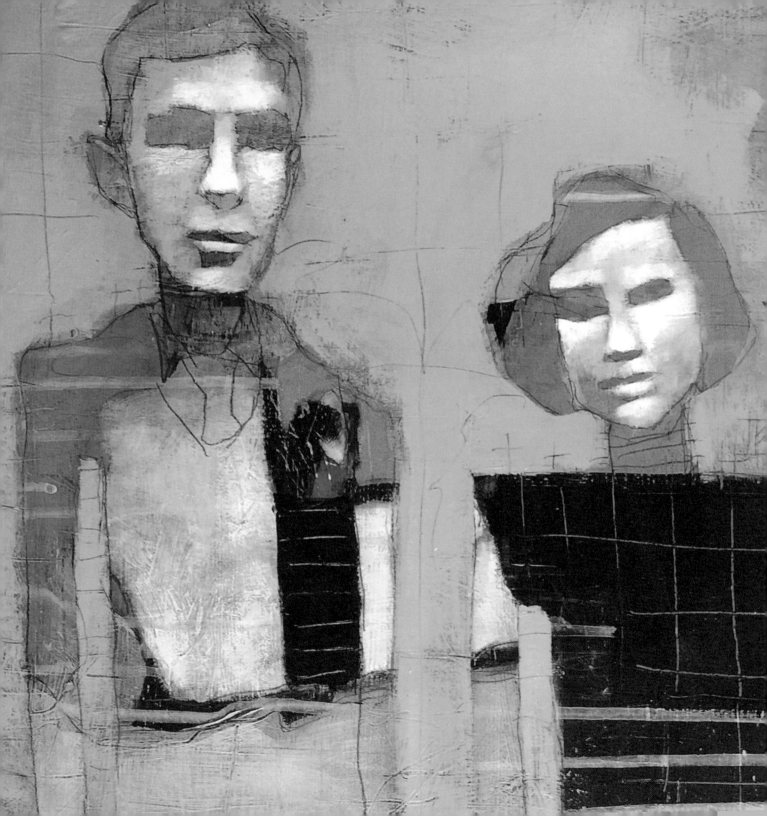

TRENT AND ASHLEY — couple from Orange County I take to PDX for flight home. They were checking out the city. First time here. Hit all the usual spots (Bollywood, Pine State Biscuits, Salt & Straw). They have big eyes for Portland. I tell them tens of thousands are expected to die painful deaths here when the big one hits. They nod their heads — eyes remain glazed. They have consumed the kool—aid.

KATYA — born in Russia, she moved here as a kid. Now married and living in Portland. Husband works for Nike. Took her from condo to PDX. Wants to go to Russia with grandparents but having trouble renewing passport. Hates Vladimir Putin. I ask why. Because he's corrupt and he takes his shirt off too much. I gotta agree. I hate bare—chested leaders.

RICK — loud, blustery guy from Chicago here to interview for a stock analyst position. Now works at Chicago Board of Trade, a stressful job. Wants to move here and trade in his old life. As I take him to Big Pink downtown, I tell him about a good friend who is the definitive Chi—town southsider — a Polish/Puerto Rican. Of course he is Rick says.

day
WEDNESDAY

miles
32

hours
3

net pay
$68

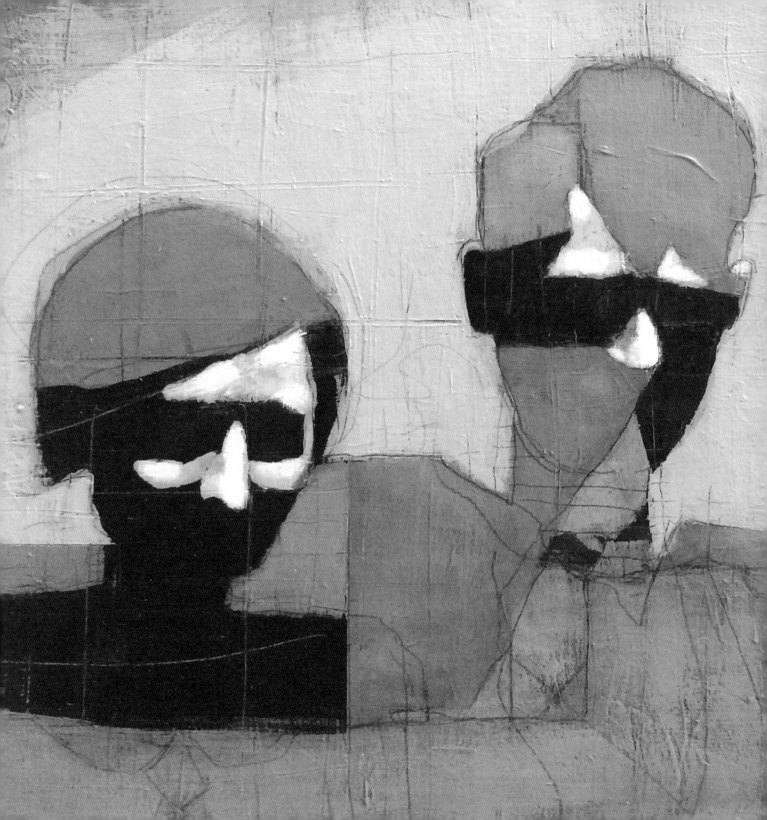

PETER AND CHELSEA — a couple random yoga instructors who fly around putting on yoga workshops in US and elsewhere. Flying to Oakland for a yoga meetup, then to Monterrey, Mexico. I was there once on an adventure traveling by train to Mexico City. Hope never to go back.

LINDA — take her to Mt. Tabor park. Meeting a friend to take in Portland sunset. Lives in Seattle where she's an ultrasound tech. Single with no plans for boyfriend or marriage or kids. A renegade who enjoys her independence. I'm a touch jealous of her certainty of what she wants in life. I still wonder.

JACK AND THREE — two couples, one from Boise, one from San Jose, meeting in Portland for weekend. Had dinner at Lewis & Clark. Uber first timers. Wondering about live music. I act cool and recommend Laurelthirst Tavern – and immediately regret it. The Thirst is the quintessential Portland bar. Keep it a secret.

day
FRIDAY

miles
48

hours
3

net pay
$51

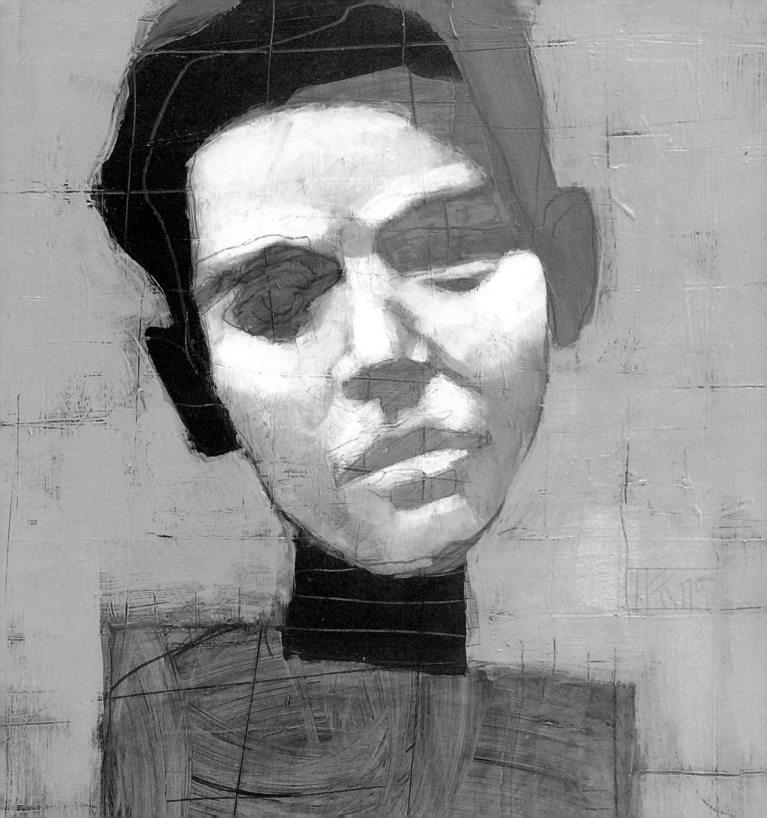

CHARLOTTE — in town from San Diego for cousin's wedding. She's eight months pregnant and left party early. I switch radio to classical for her unborn to hear. I've heard classical is what to play for babies. But they're playing Bach who's a bore so I change it back to rock station. Talking Heads. Now we're talking.

MEGHAN — a bartender who lives in N. Portland. I take her to pick up a guy friend and drop them at an Egyptian bar. Why this place I ask? Affordable drinks and they like the bartenders. I ask what they drink. Manhattans. Or Mojitos. Depending on their mood. What about margaritas I ask? Nope they say – ending the alliteration. Again, I almost knock off and go inside with them. But don't want to muck up their night.

RYAN AND PAL — take them to White Owl Social Club to continue their Saturday night bar attack. They appear under control and I say so. They laugh and scoff at a friend they saw earlier who was already gonzo. Too early to be out of it they say. He's a rank amateur. We all were once.

P

day
SATURDAY

miles
30

hours
3

net pay
$48

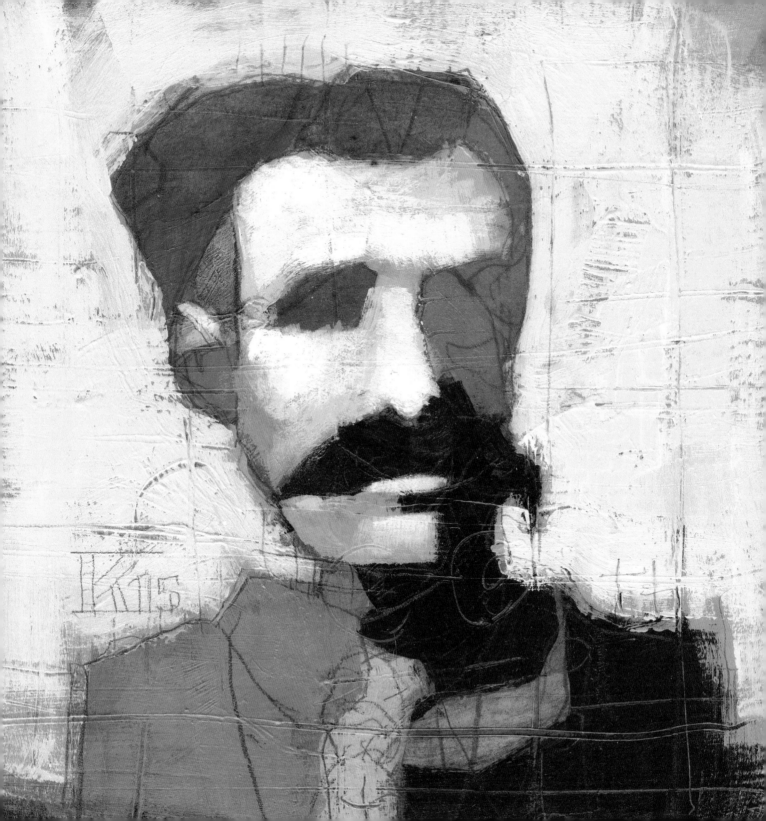

SHAWNA — deliver her to Pearl condo where she and husband have just moved. Downsizing. Now empty nesters — entering new territory. Seems excited, like a freshman moving into her dorm. Can't help myself so I say I'm proud of her and that she has an exciting future in front of her and not to party too much. She promises not to.

REX — pings me to take him to rehab. Tore his ACL skiing outback at some remote spot in Canada (he claims). Painful as hell, toughest thing he's ever done he tells me. But I see no grimace as he hops out, and there's no sign of sun on his pale face. I begin to doubt his story. He's probably never set foot in Canada. He's out the door before I can call bullshit.

JEFF — take him to work at a local brewery. Left his car there last night and took Uber home. Partied a little too hearty. Bloodshot eyes like two hardboiled eggs in V8. I know that look — from both directions. I turn the radio down. Greasy junk food is the cure I tell him — with a vanilla shake. Trust me.

day
TUESDAY

miles
60

hours
3

net pay
$66

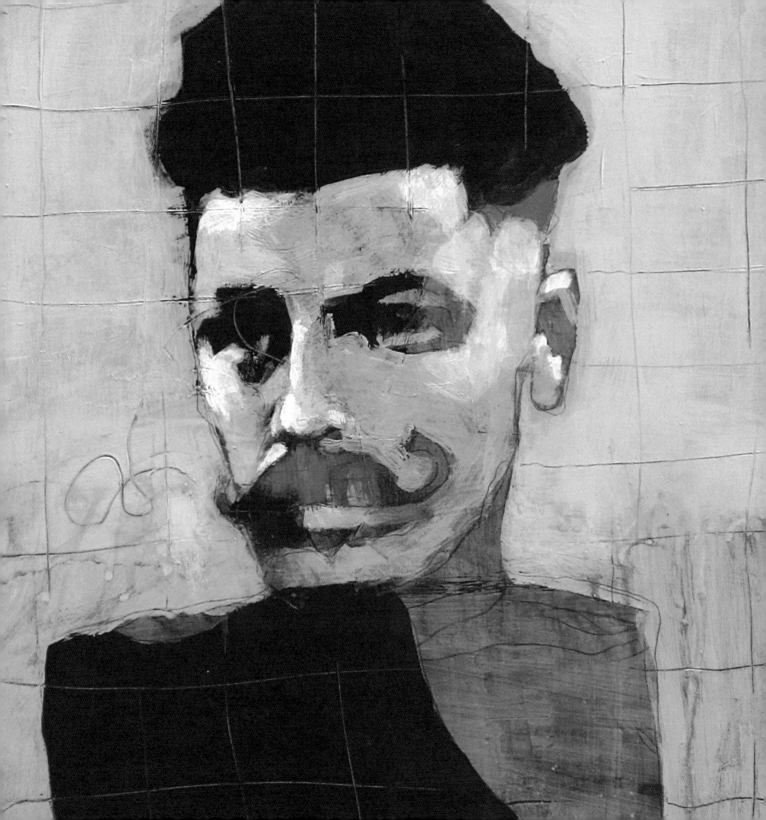

RUDY — deliver him to his job at a community bank. Makes small loans to businesses and nonprofits. Sounds righteous I say. I have a small business I tell him – Les Overhead it's called. He thinks I'm joking, but it's true. Can I get a loan I ask. He stiff arms me. Wellll, you can put in an application. Upon arriving, he jumps out – faster than needed it seems. He doesn't look back to see if I'm coming in with him. I peel out. I don't need no stinkin' loan.

BARRETT — mid 20's guy who works in data analysis. Undergrad from Harvard, then went to Stanford for Masters in Computer Science but dropped out to work (was making mad scratch I think is the phrase). Now flying to SF to interview for job with Uber. No shit, I say. I start gabbing a mile a minute, burying him in an avalanche of insight. Once finished, I tell him he's a shoo–in. But I'm not so sure. Seems kinda flighty.

STEVE AND BUDDY — both are chefs but neither is working now. Heading to eat at a small, unknown place (under the radar they say – and sonar too). They begin talking about the best casino dining in Vegas. They love the casinos; the buffet cuisine is wonderful they swoon. I instantly lower my regard for them. I wonder if this unknown restaurant we're bound for is really that good. I'd lay money against it.

day
WEDNESDAY

miles
56

hours
4

net pay
$72

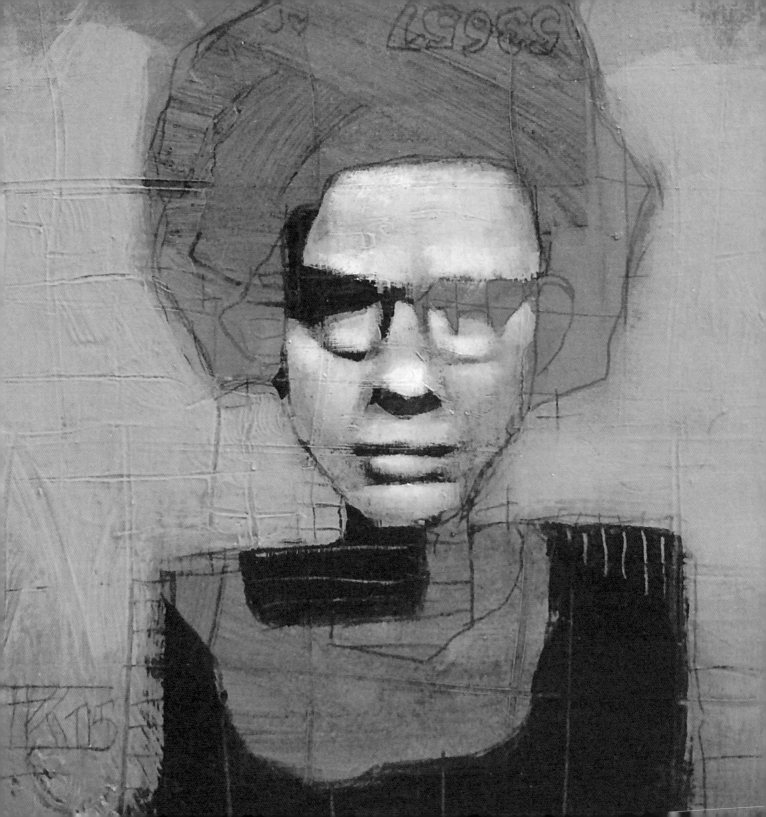

CRYSTAL — dressed nice with silk blouse and pearl necklace. Meeting a guy at the White Eagle. It's a date, but one where the guy meets the girl at a bar. Supposed to be a good band tonight. Garcia Birthday Band. I like them, I say. You'll be grateful you went (emphasis on grateful). She misses the pun. When we pull up a lanky lumberjack in checked shirt and dense black beard steps up and opens her door. Her date. They don't seem matched. Could be a long, strange night.

SUZANNA — from Hungary. She's lived here about nine months. I transport her home from restaurant downtown. First time Uber rider — her husband suggested it. When I ask where he is tonight, she pauses. Did I cross the border? Is that creepy of me to ask a woman, alone, whom I'm dropping off at a dark home? Probably. I can hear my daughter, Ruby. Dad, shut up!

ELIZABETH - in town from NYC. Take her to Breakside Brewery to meet coworkers. She asks if all of Portland likes the Decemberists. I detect a sneer and say, don't you? Not sure. I've never heard of them but everyone keeps mentioning them. What's with their name? It's some Russian group from way back I tell her. They were really good. Oh, okay.

day
THURSDAY

miles
49

hours
3

net pay
$54

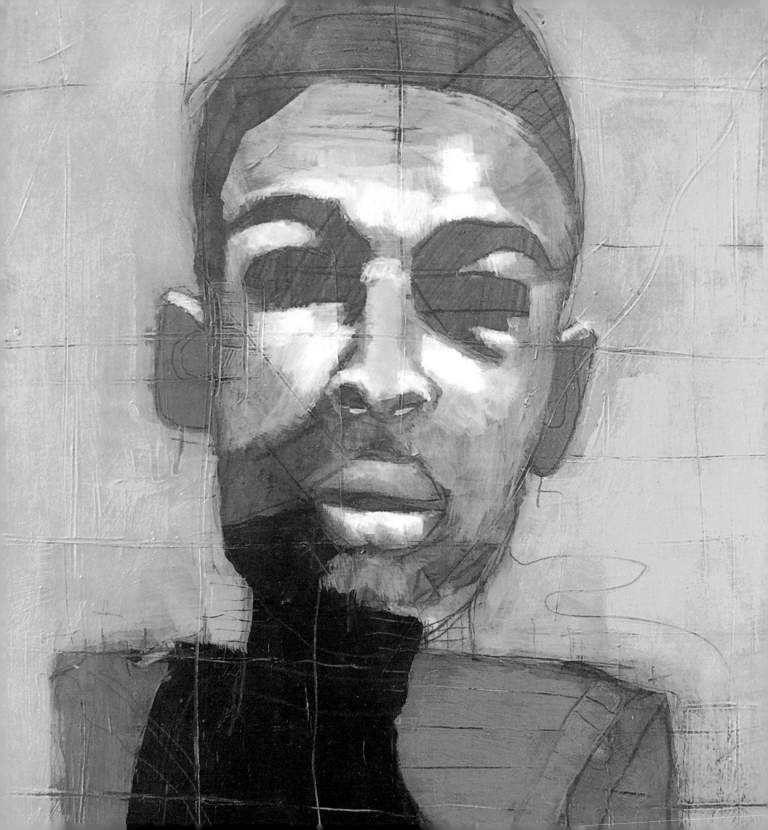

RODERICK — freelance photographer from Wash DC (one of the only black riders I've had). Here on assignment for national magazine to shoot Portland hip spots. Wants to go to the skate park under Burnside bridge, nobody there. Then take him to Voodoo Doughnuts. Takes some shots but is more focused on getting a donut. He gets in line. I roll my eyes and roll on.

MICHIKO AND HUSBAND — take them from SE bistro to downtown Portland hotel. First time in Portland. Live in Baltimore. They asked their daughter who lives in Manhattan what city in US they should go visit. She said Portland, Oregon. So they flew out. Sushi has been good, clam chowder just so—so. I say welcome to town but don't stay too long. They don't laugh, say they won't.

ALFREDO AND WIFE — in a crowd I find them, outside Roseland Theater. Concert just let out. Monsters and Men. Wish I'd seen it, I say. They're a Seattle band aren't they? Trying to show off my indie music chops. No, Iceland, they respond. We argue about it and they look it up on phone. Damn, Iceland. I'm a few thousand miles off. They see I got no chops.

day
SATURDAY

miles
28

hours
2.5

net pay
$41

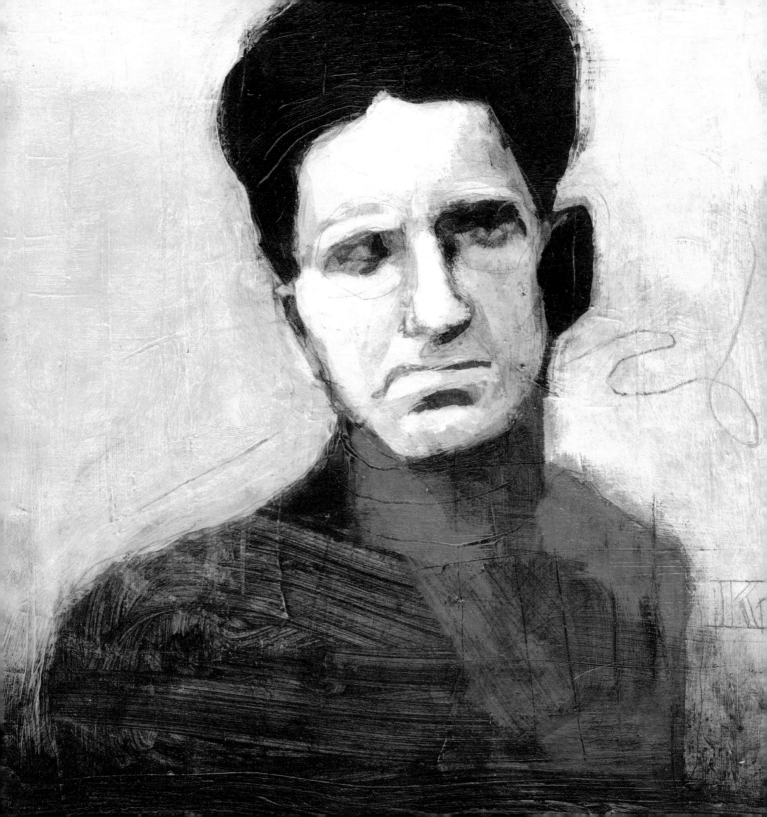

RICHARD — take him to PDX to fly home to Austin. Came to Portland for friends' wedding who had eloped. He was one of only two witnesses. Elope, I say? Must be family problems. My forthright tone doesn't faze him. Nope, they just wanted to get married here. Portlandia – where young people go to elope and retire.

NICOLE AND FRIEND — take them to Blue Fin Sushi in Hollywood. Visiting from Napa, CA. First time here. Amazed how green it is. I say there's excellent Pinot here too. Mr. Smooth Travelguide. As if I'd know a good Pinot from a god—awful one. I'm no sophisticate. But I can play one when driving strangers.

LILA — she apologizes the minute she climbs in. Why? Because she needs a ride about five blocks is all to New Seasons. Sorrrrry she says. Has sore back and didn't want to walk, husband is gone with their only car, and the store closes in 10 minutes. Needs Panini bread to make sandwiches. Lame excuses. Lowest fare yet – a measly five bucks.

day
MONDAY

miles
38

hours
2.5

net pay
$32

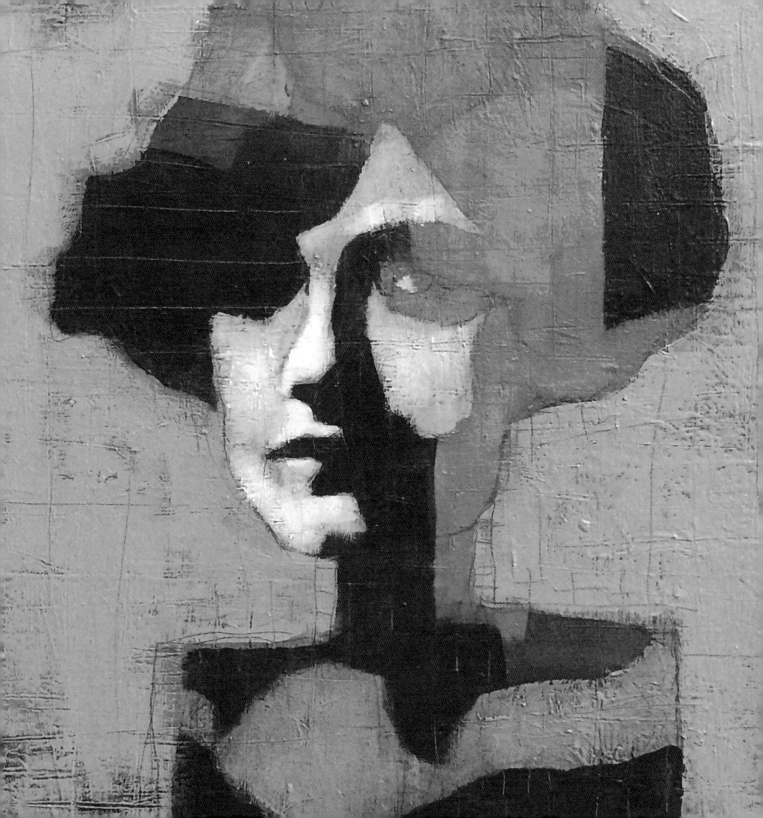

KENNETH AND WIFE – ping me from Sweet Basil Thai restaurant. In town from San Jose to see a Portland friend, who is now loudly drunk in restaurant and being obnoxious. They told said friend they were tired and going back to hotel but actually had me take them to another bar. They felt bad about ditching her, but not that bad. I didn't feel bad either. Obnoxious drunks are the worst. I've been one.

HAZEL — young designer who has her own clothing line for boys and girls. I take her to PDX to fly home to LA. Says she's amazed how many little boutiques and designers there are in Portland. Used to work for Nike in LA then went on her own. Another Nike offshoot. I wrote some golf catalog copy for them once. A hellish job that had me reaching for the Canadian Club.

CASSANDRA — take her to bistro in Pearl. Quiet. Says just two words: "No problem," when asked if she hates Hawaiian music (playing on KBOO). I turn it down anyway. Some people detest Hawaiian music. I ask what music she really hates. Heavy metal. And polka. I tell her I love heavy metal polka. I change the station.

day
WEDNESDAY

miles
46

hours
2.5

net pay
$36

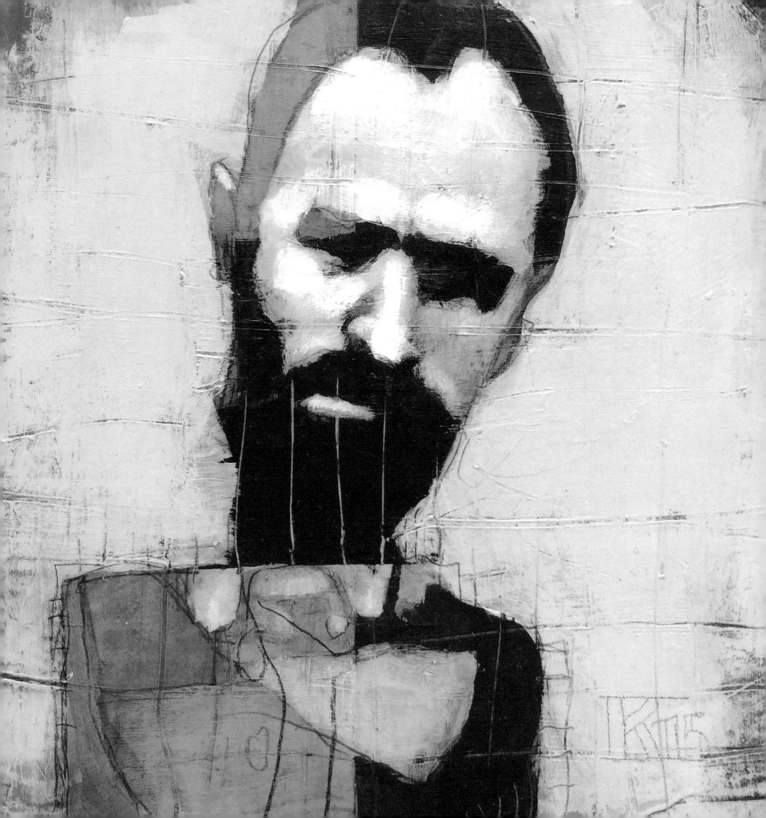

RANDY — take him down I—5 to Kruse Way, Lake Oswego for work. Usually car pools but his coworker's car broke down so he's Ubering. Moved here from New Jersey six months ago. Bored, I ask if he's in the witness relocation program. He looks the part. Dark hair and thick brows that are hiding something. He denies it, which of course he would. I eye him in the rearview the rest of the way to make him nervous. Boredom makes me do strange things.

MAXINE — pings me from up in Mt. Tabor park. Finally find her. She and boyfriend were waiting for Parks guy to open gate so they could get their car which got stuck there overnight. Gate closed at 10 pm. They missed it by two minutes. Parks guy still not there but she has to get to her job. Timing is everything. Hope she's on time for work.

T — thought with just a one—letter name it would be a woman, but it's a guy. Small stature, shaved head, sharp glasses. He immediately calls someone. Says, this is Tommy. Once he hangs up I say that's funny, I'm a Tommy, too. Like kids who haven't grown up, he says. Some truth to that. But for a Tommy, he's not that friendly. Too self—absorbed. Giving us a bad name.

day
THURSDAY

miles
52

hours
3.5

net pay
$64

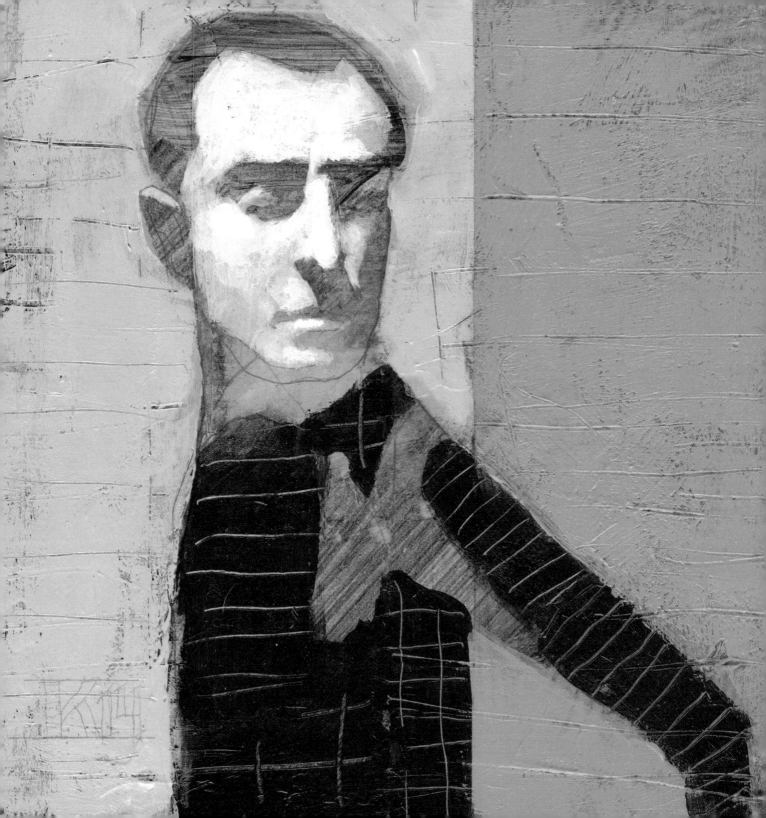

MAYUR — a Brit from London. Works as a coffee salesman. I say that's a long way to fly to sell some beans. I ask for vacation tips. Majorca, Spain is his go—to spot. He asks me where I like to go. Astoria, Oregon. He's never heard of it. Good, I say. We don't need no redcoats invading. He laughs — thinks I'm joking. I'm not.

STEPHEN AND COWORKERS — three guys in suits. Take them to some office/industrial park way out in Clackamas. In town for food trade show — reps for an organic snack company. Travel a lot. I ask about worst airports. Detroit says one. Dallas says another. Third guy says Philly. All agree on that. Thank god I just drive, not fly. Would love to drive to Detroit.

BETH — traveling ER nurse from Michigan, now living in Portland. Take her to get her car at hospital. Job is tough on relationships. She's down on men. Last two boyfriends both screwed her over. One broke up a day after giving her his apartment key. Wuss. Another cheated on her with a Russian coed who went to Michigan State (rival school — that's cold). I tell her not all guys are jerks. But I've been one. Most likely we all have one time or another.

day
FRIDAY

miles
78

hours
5

net pay
$104

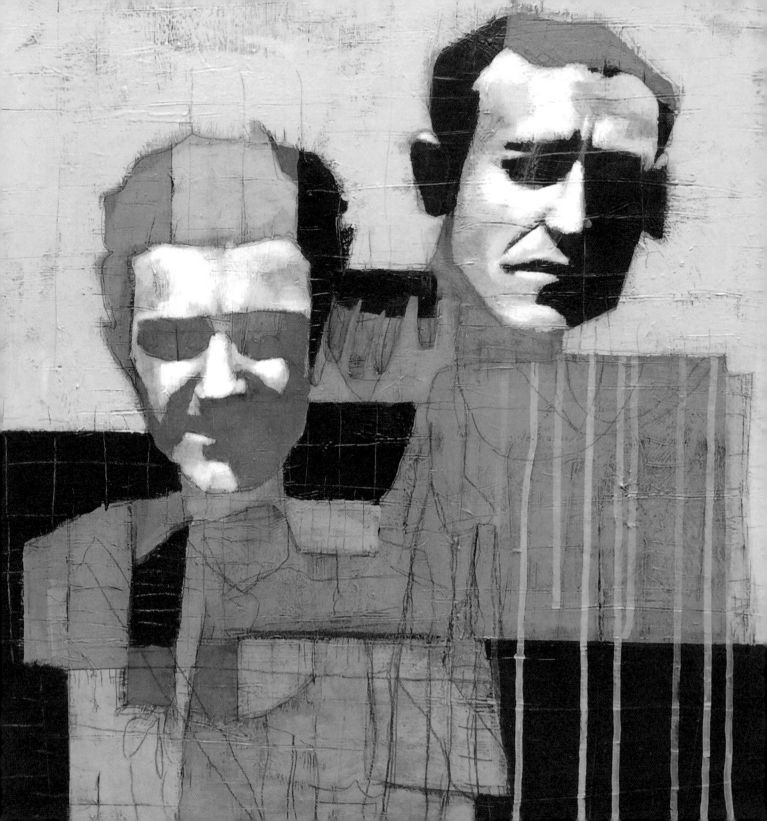

JASMINE - pings me from Vendetta Bar and I ferry her to Beaverton. Was out for happy hour with her nanny. Seems pretty happy and slurs almost every word she utters. I think about the plastic puke bucket I have in the back and wonder if she may need it. To keep her head from spinning, I engage her and ask who's watching the kids. My husbo. Hiccup. I keep talking and speed up.

MARTHA — pick her up a few blocks from Jasmine's. Only needs to go about five blocks, but her knee is sore so called for Uber. Bet her knee is just fine. Drop her at a Greek restaurant/bar where she plans to play dominoes. Big Friday night for her.

JOHN AND BUDDY — out carousing. I take them to Whisky Bar in Old Town, a place I've never been and make a note to check it out. As a bar devotee, I like discovering new places. Frankly, I love bars more than I love driving, which is a lot. But I don't have a problem – and not ready to knock off yet. So I motor on.

day
SATURDAY

miles
39

hours
3

net pay
$46

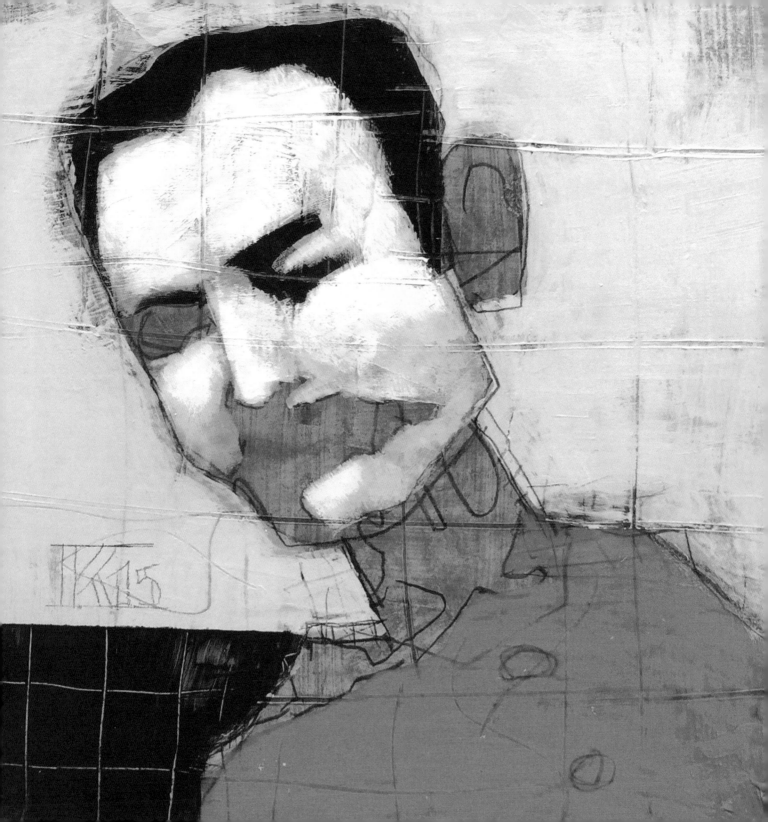

LULU AND FRIENDS — she and a friend jump in and say wait, more coming. Three guys arrive and pile in. I probably should tell them that's too many. But it's late. One sits on another's lap and we take off – to Lake Oswego. One guy forgot his ID and couldn't get in anywhere downtown. So it's back to their burb. Raunchy, loud comments. The ladies are out of it and swear incessantly like they've just learned how.

SAMUEL — here by himself to check out Portland. From Israel, now living in LA. Goes to a different US city every month. Likes New Orleans best so far. Gotta agree there. Thinks Portland is a bit sleepy. Everything shuts down at 2:00 am. He's unimpressed. Tel Aviv kicks Portland's butt he says. Yeah, but how are their donuts?

MARTY — one last ride for the night. Finally locate him at intersection in Old Town where people throng after bars let out. Run him and his crew of three across the Columbia to Vancouver. Within minutes, the aroma of herb arises. They offer me a hit, but I decline. Claims he grows killer weed and writes his number down. Says call me, seriously. I say I might, not seriously.

day
SATURDAY

miles
59

hours
3

net pay
$54

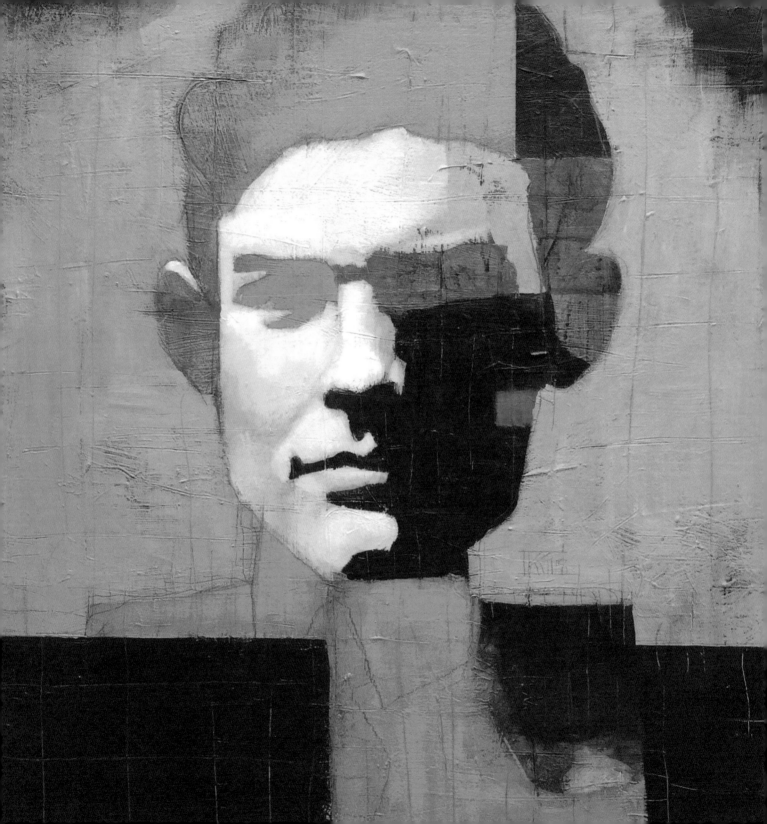

DAVID AND COWORKER — in town for conference. But skipping morning session to hit Pine State Biscuits. Were told by folks to go there no matter what. Acted like they were skipping school — truants! I should turn around and turn them in. But I don't. In truth, I'm glad to help others stick it to the man. Even if the man is a food trade show.

DOUG — he and buddy imbibed too much last night. Left his car downtown and took Uber home. I deliver him to his wheels. I can hear the hangover in his weak voice. Says his buddy almost lost it in the Uber driver's car coming home. Driver told him it's a $250 fee for puke cleaning (he made it up). His buddy held it, then blew chow in the bushes when they arrived. Poor shrubs.

MING — a wispy waif moving from a friend's house to a new apartment. Grew up in Seattle and is now striking out on her own — all the way to Portland. Baby steps. I load boxes into my car and ferry her to her new digs. We carry her stuff in and she thanks me profusely. Reaches into her purse for a tip, but can only produce one solitary buck. I think she'll feel better if I take it, so I do and wish her luck. She'll need it. We all do starting out.

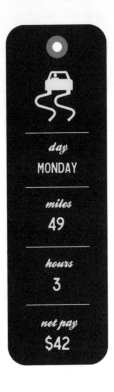

day
MONDAY

miles
49

hours
3

net pay
$42

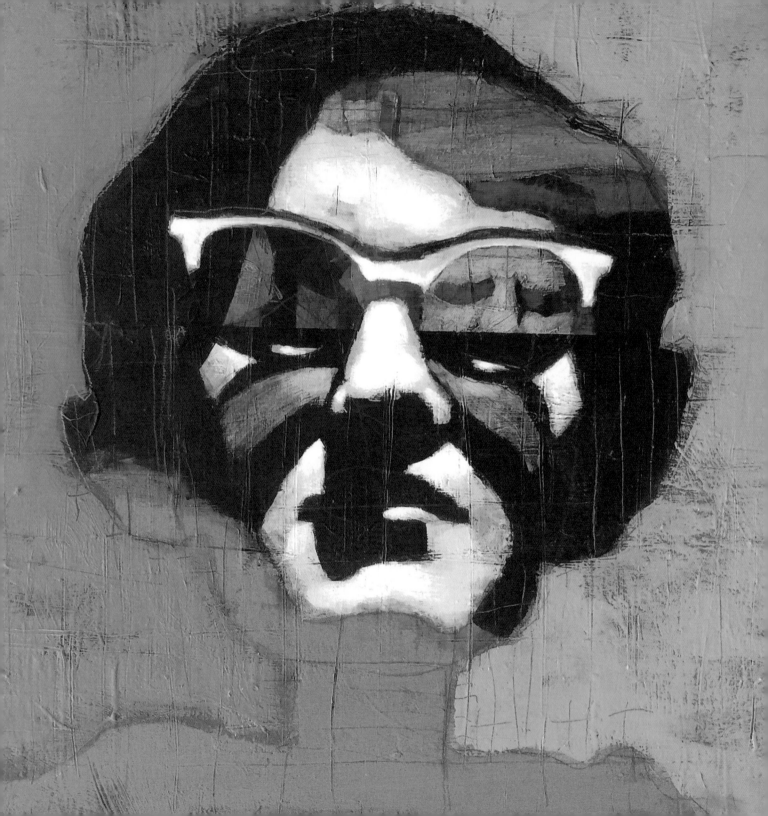